ARTIST'S STUDIO

CONTEMPORARY
WATERCOLORS

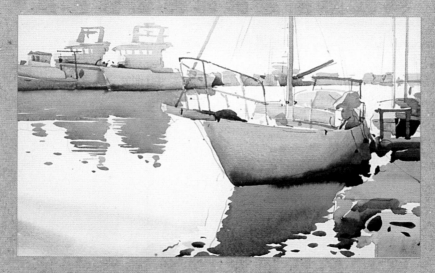

Featuring Winsor & Newton Colors and Products

with George Butler, Karen Kluglein, Nick Poullis, and Charles Sluga

www.walterfoster.com

Walter Foster Publishing, Inc.
3 Wrigley, Suite A
Irvine, CA 92618
USA
www.walterfoster.com

Associate Publisher: Rebecca J. Razo
Project Manager: Elizabeth Gilbert
Art Director: Shelley Baugh
Senior Editor: Amanda Weston
Associate Editor: Stephanie Meissner
Production Artists: Debbie Aiken, Amanda Tannen
Production Manager: Nicole Szawlowski
Production Coordinator: Lawrence Marquez
Production Assistant: Janessa Osle

Contents

Introduction

Watercolor is a fresh and luminous medium that allows for both traditional and avant-garde approaches.

Regardless of your art style or skill level, *Contemporary Watercolors* is your guide to understanding essential information about a variety of watercolor tools, materials, and techniques to expand your creative toolkit.

Featuring a selection of Winsor & Newton artists' mediums and materials, four accomplished artists share their expertise on everything from brush shapes, paper surfaces, and palettes to painting techniques and styles. Karen Kluglein reveals how to set up an effective studio and offers an in-depth look at paintbrushes. Nick Poullis examines watercolor papers and demonstrates how to use each of Winsor & Newton's innovative mediums. George Butler shares his thoughts on palettes, unconventional tools, and working on site. Charles Sluga discusses paint, pigments, and color mixing. Finally, the artists share their favorite techniques and showcase some of their beautiful artwork, each offering a unique perspective that is sure to inspire you.

There has never been a better time to explore the world of watercolor with Walter Foster and Winsor & Newton. Enjoy!

Watercolors have a long history. One could argue that the medium first appeared during prehistoric times, when early humans used simple mixes of pigment and water for cave paintings and body art. During the time of the Pharaohs in Ancient Egypt, artists added gum arabic as a pigment binder, creating a mixture that is still the basis of watercolor paints today. In the 18th century, watercolors were available in the form of small, long cakes of pigment that had to be rubbed down with water.

Watercolor paint is a combination of pigment, binder, and small amounts of a few other ingredients. Gum arabic serves as the binder in watercolors, and the best quality is Kordofan (from the Acacia trees of Africa's Kordofan region). Other ingredients include ox gall, glycerin, and preservatives. Ox gall is used as a wetting agent that helps control the spread of the watercolor across the paper. Glycerin is a moisture-retaining ingredient that is essential for moist tube watercolor paints. Preservatives prevent the gum arabic from molding.

Winsor & Newton Watercolors

In 1832, William Winsor and Henry Newton dramatically changed the world of watercolor by adding glycerin to the paint formula, creating the first moist watercolor paint. This allowed artists to paint with a wet brush and, combined with the invention of the collapsible metal tube, made watercolor painting accessible to the masses and more conducive to *plein air* painting, or painting outdoors. Today, watercolor is the most popular paint medium in the world.

Winsor & Newton produces a range of nearly 100 paints that cover the entire spectrum of colors. They are available in both pans and tubes. Pans are moist blocks of paint that are perfect for producing small studies. I prefer tube paints because they create richer, darker colors and allow me to use larger, more fully loaded brushes for bigger and bolder paintings. The Winsor & Newton Artists' Water Colour range is a professional, top-quality line with high-pigment strength and beautiful flow capabilities. Winsor & Newton Cotman watercolors (value range) use less expensive pigments to provide a desirable mix of quality and affordability in 40 colors.

SECTION ONE

Getting Started

*with George Butler, Karen Kluglein
& Nick Poullis*

- Setting up a Studio
- Working on Site
- Paintbrushes
- Watercolor Paper
- Mixing Palettes
- Unique Materials

Setting up a Studio with Karen Kluglein

Throughout my life as an artist, I have worked in many different spaces—from a tabletop easel in my bedroom to a beautiful designated studio space. It is possible to create artwork no matter how limited your space is—you may even prefer painting on site (see opposite page). As you set up your indoor studio, remember that the three most important elements are lighting, workspace, and storage.

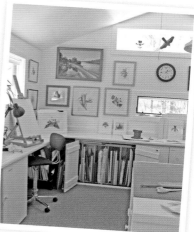

Lighting

Good lighting is key to an inviting and efficient work-space. Many artists dream of a space with plenty of north light (which you would get with a north-facing window); however, artificial full-spectrum light can work just as well. Full-spectrum bulbs mimic natural daylight and enable you to see colors accurately. Try to light your entire workspace from above, in addition to using task lighting directly above your table or easel. In my studio, I painted the room and cabinets white so they do not interfere

Here you can see the basic layout of my studio. Notice that my white walls are far from bare. Don't be afraid to hang artwork for inspiration!

with the colors in my paintings. The room has skylights and a few overhead lights, as well as task lights around the room, so the studio stays brightly lit at all times.

Workspace

Another important element is a flat surface for spreading out your work and supporting a tabletop easel. From sketching and painting to laying out supplies, matting, or framing, you will probably need more than one surface. The more work tables you can find, the better. My studio is configured with counters along two sides (one with a sink), easels along the third side, and an island in the center of the room. The fourth wall has a white pegboard that allows me to move paintings around without putting holes in the wall. For entertainment and comfort, my studio also features a TV, radio, air-conditioner, and dehumidifying system.

Storage

Storage in various configurations will help you stay organized. Large, flat shelves work well for storing your paper flat, whereas vertical storage is great for frames or glass. Drawers can hold small paints or supplies, and filing cabinets can store paperwork. The island in my studio has a mat-cutting surface and horizontal shelves for storing various types of paper. A drawer holds smaller tools, and I hang rulers, triangles, and clamps on the side of the island for easy access. The more organized you are, the more efficiently you can work—and the more time you can spend painting.

Working on Site with George Butler

I believe there is no better way to work than from life, on location. In the presence of your subject, there is a pressure to paint what you see with immediacy, forcing a fluency that would be difficult to create in a studio. Working in this manner has its challenges, but the rewards are well worth the effort.

©Shutterstock

A typical on site painting set up.

Equipment

Easel and Stool: The most important tool is an easily portable, lightweight easel. For convenience, purchase the smallest easel that supports the size of your work.

Drawing Board: Your board should be light enough to carry and maneuver easily. I find that a medium-density fiberboard works well for sizes up to 18" x 24".

Paints: Painting on site provides the opportunity to experiment with a limited palette. Leave the big tubes in your studio, and practice working from a small tin palette instead.

Camera: Cameras are great for painting on location, but refrain from taking a photo for the sole purpose of painting the scene in your studio—at least 85 percent of the work should be done on site. A photograph can, however, help you perfect fine details.

Tips for Setting Up

After you've selected your subject, find a space where you have enough room to work with your materials comfortably. There is no one right way to set up, but note the following considerations before getting started:

Movement: Cars, trucks, and people move, but this is all to be welcomed. Painting over a period of time allows you to document common behaviors that a camera cannot catch.

Time of Day: A beautiful building can be difficult to describe in flat light, especially for a watercolorist. You may find it necessary to leave and return the next day when the shadows are similar. Also, I advise painting the scene as the light changes, which can make your painting feel alive.

Weather: In unfamiliar locations, unpredictable weather may influence where and how you work, but don't let that stop you from painting. You want to record your subject as it appears in its natural setting.

Paintbrushes with Karen Kluglein

Material

Watercolor brushes are generally made from sable, squirrel, or synthetic hair. Kolinsky sable brushes, which are made from the hair of a male Russian red sable's winter coat, are widely viewed as the best. These brushes hold a surprising amount of water and keep their shape well. Because these brushes hold so much pigment, they allow you to paint for an extended period of time without reloading your brush. The fine, soft hairs are brown with dark tips. Kolinsky hairs are from the sable's tail; hairs from other parts of the sable are less costly and do not as readily spring back to shape while painting.

Synthetic-hair brushes mimic (but do not match) sable brushes because they can hold a good amount of paint and keep their shape. These brushes are a good choice for beginners or those on a budget. A blended brush, which contains both natural and synthetic hairs, can bring you closer to the qualities of a sable while offering the affordability of a synthetic; however, keep in mind that even a good synthetic brush will not last as long as a sable brush that has been cared for properly.

Size

Round brush sizes are designated by a number, which is located on the handle. The larger the number, the larger the brush. (For example, a #6 brush is larger than a #2.) Your subject matter and the size of your painting should determine the brush sizes you use. A good starter set of brushes might include three round brushes (#2, #4, and #6), a ¾" flat brush, and a #6 Petit Gris wash brush.

Watercolor brushes are designed for optimal control of a fluid medium. In addition to considering the material, shape, and size of the bristles, look for these three important characteristics when selecting your brushes:

1) The bristles should come to a fine point so that you can create precise detail.
2) The bristles should spring back to shape after each stroke.
3) The brush should deliver a consistent, even flow of pigment to your surface.

Shape

Choosing the correct brush shape depends on the effect you are trying to achieve. Below are the most common brush shapes used in watercolor painting.

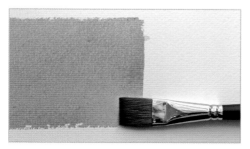

A large *flat* brush is great for laying in color with horizontal strokes. You can use a smaller flat brush for controlled edges and shapes. The hairs, which are the same length, are pinched at the ferrule.

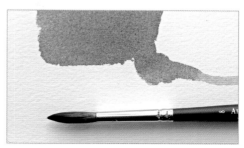

Round brushes have hairs that "belly out" in the middle and taper softly at the tip. They hold a good amount of water and are great for washes, fine lines, and detail work. Because of their versatility, the round is the most popular brush shape.

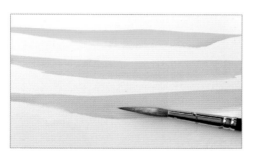

Pointed *round* brushes are round brushes that come to an even finer tip. This shape produces elegant strokes that can vary greatly in width.

A *rigger* is a small brush that can create a continuous fine line for scroll work and detail. It is the longest and thinnest round brush, and it has a very precise point.

A *wash* brush is a round brush with a thick base and bristles that taper to a point. These brushes are designed to carry large amounts of water so you can quickly and evenly apply a wash (or wet the paper).

A *filbert* is similar to a flat brush, but the edges of the hairs are rounded to a dome shape. It is most often used for blending or blocking in large areas of color.

A *fan* brush is good for soft textural effects or blending. Used with damp (but not wet) hairs, the fan brush can create natural looking grasses.

Brush Care

Washing your brushes after each use is essential for maintaining the shape and quality of the bristles. Wash your brush using warm water and mild soap. Under running water, dab the brush in your palm to remove leftover pigment. Swirl the wet brush into wet soap and gently work it into the bristles. Rinse the brush until all the soap is removed. Repeat this process until the brush no longer leaves pigment on the soap. Gently blot the brush on a paper towel; then shape the damp bristles with your fingers, carefully bringing them to a point. Lay the brush on its side to dry.

Artist Tip

Treating your brushes gently and keeping them clean can help you avoid loose or stray hairs, which can ruin a work in progress.

Do's & Don'ts

- Don't let paint dry in your brushes.
- Do store brushes in a clean, dry area.
- Don't let brushes stand bristle-side down.
- Do use watercolor brushes only for watercolor or gouache.
- Don't use sable brushes to apply frisket or masking fluid.

Winsor & Newton Watercolor Brush Lines

Winsor & Newton offers a wide variety of watercolor natural-hair and synthetic-hair brushes. The top-of-the-line **Series 7 Kolinsky Sable** brushes are soft, hold plenty of water, have a fine point, and spring back to shape. The **Artists Water Colour Sable** brushes are quality Kolinsky brushes with a sculptured handle for added control and comfort. The **Wash & One Stroke** line, which are made from various natural hairs, including goat, pony, or squirrel, hold quite a bit of water and cover large areas quickly. They provide excellent color-carrying capacity and flow control. Winsor & Newton's synthetic **Cotman** brushes have slightly stiffer bristles than the natural sable brushes. They do not hold as much paint, but they are still suitable for a range of applications.

The tools we use can make our work easier and more enjoyable. Purchasing the best quality of brush that you can afford is ideal. My personal preference—and the one I recommend to my students—is the **Winsor & Newton Series 7 Kolinsky Sable** brushes. The brushes are a pleasure to work with and are worth every penny. Experiment with a variety of Winsor & Newton brushes to discover which works best for you.

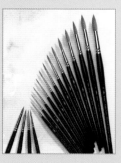

Series 7 Kolinsky Sable Brushes

Artists Water Colour Sable Brushes

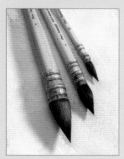

Wash & One Stroke Brushes

Cotman Brushes

Watercolor Paper with Nick Poullis

Watercolor is largely affected by your choice of paper surface. In fact, it is commonly said that artists paint using the paper. Your painting surface works in tandem with the brush to create your marks, so use a light touch as you allow your surface to respond to the brushwork. With practice, you will develop a feel for how the paper, brush, and paint interact. A variety of watercolor papers are available, and you'll find that some are more suitable than others for creating the effects you desire. Choose a paper that allows you to bring out the qualities that best complement your style and subject, and for long-lasting work that does not yellow over time, choose an acid-free, pH-buffered paper.

Paper Properties

Watercolor papers vary in thickness, which is described as weight measured in grams per square meter (gsm) or pounds per ream (lb). Standard machine weights are between 190 gsm/90 lb and 638 gsm/300 lb. Light papers may need to be stretched before use to prevent buckling. Stretching involves soaking the paper, adhering it to a flat surface, and allowing it to dry. Papers can be purchased pre-stretched in a block. Whether you stretch also depends on the size at which you wish to work. Because I never work on light papers larger than 10" x 12", I do not stretch.

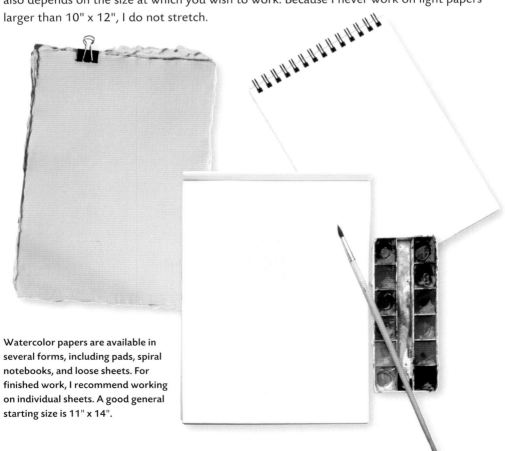

Watercolor papers are available in several forms, including pads, spiral notebooks, and loose sheets. For finished work, I recommend working on individual sheets. A good general starting size is 11" x 14".

Sizing, a substance used to coat the paper, helps determine the character of the surface. Sizing reduces the paper's ability to absorb liquid, allowing paint to dry on the surface rather than soak and bleed into the fibers. Paper is either hard-sized (with good resistance) or slack-sized (with little resistance).

Papers also vary in brightness and color, which affect the luminosity of the paint. Bright white, gray, off-white, and cream papers are common—and each one creates a different tonal effect. Some papers are tinted with colors such as blue or pink, which can have a great impact on how your paint appears. To create highlights on tinted paper, you can use gouache paint (opaque watercolor).

Watercolor papers are made either by machine or by hand. Handmade papers vary considerably and are often non-standard sizes, surfaces, and weights. For a lower cost and ease of availability, most artists opt for machine-made watercolor papers. Although all types of paper vary slightly depending on the manufacturer, machine-made watercolor papers are available in three main categories: hot-pressed, rough, and cold-pressed.

Winsor & Newton Water Colour Paper

Artists' Water Colour Paper – Available as loose sheets in 90 lb/190 gsm, 140 lb/300 gsm, and 300 lb/640 gsm weights, this quality paper is a favorite of professional watercolorists. The 300 lb paper is available in cold-pressed and hot-pressed, whereas the remaining weights come in all three surface textures. The paper is also available in a range of pads (gummed and wire-o) in 140 lb/300 gsm weights.

Cotman Water Colour Paper (cold-pressed) – Perfect for students and beginning artists, Cotman cold-pressed paper is available in 90 lb/190 gsm, 140 lb/300 gsm, and 200 lb/425 gsm weights. The paper is also available in gummed pads, spiral pads, and postcards of various weights and sizes.

Rough Paper

Rough watercolor paper has a promi-
nent *tooth* (or textured surface). When
the paper is coated with a wash, paint
collects in the indentations to create
a granular effect. This surface is ideal
for the drybrush technique, where the
brush lightly skips across the paper to
create coarse strokes. (See "Drybrush,"
page 58.)

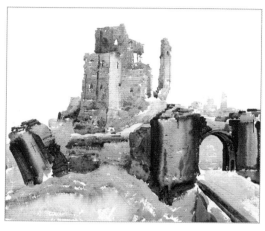

Because rough paper suits a broad,
painterly style, it is useful for hinting
at subjects instead of portraying them
with minute detail. For example, you can use the texture to describe a crumbling wall
rather than faithfully rendering each stone. The grooves and dips of rough paper also
assist in granulation, which gives areas of color depth and interest. (See "Granulation
Medium," page 40.) The course texture of rough paper worked perfectly for rendering
the weathered walls of *Corfe Castle in Dorset, England* (above).

Hot-Pressed Paper

Hot-pressed paper has a very
smooth, fine-grained surface with
little or no tooth. For these rea-
sons, it is widely used in printing.
For the watercolorist, hot-pressed
paper offers a bright painting sur-
face and good luminosity. Paint
dries quickly on its surface with
little granulation, making it ideal
for smooth areas of wash, detail

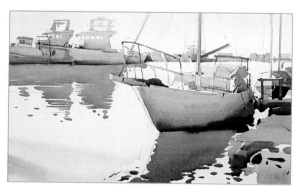

work, and small-scale painting. This surface effectively accepts deep, rich washes.

I find hot-pressed paper to be less versatile and less forgiving than others, so I don't
use it often. On this smooth surface, the paint can "tree" easily (a process wherein the
pigment pools and spreads across the paper in streams), so it's important to allow each
layer of paint to dry fully before applying the next. Also, any dirt or fingerprints on hot-
pressed paper can disturb a wash; therefore, careful storage is crucial. In *Boats Along the
Herault* (above), the smooth, bright nature of the hot-pressed paper gives the scene a
luminous serenity.

Cold-Pressed Paper

Cold-pressed paper (also called NOT paper) is generally considered the most versatile surface, especially when hard-sized. The surface offers a texture between that of rough and hot-pressed papers. Cold-pressed papers allow some drybrushing and granulation, but the texture will not affect the look of a painting as dramatically as with rougher papers. Hard-sized, cold-pressed paper allowed me to create controlled lines while exhibiting subtle texture for interest in *The Three Graces* (below).

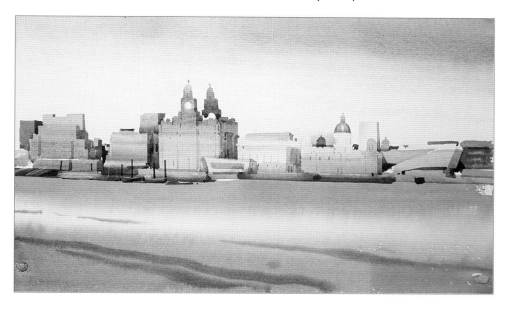

Choosing Your Paper

The paper surface you choose should depend on the aspect of your subject that you wish to capture. Think about the kinds of marks and effects that might be necessary for portraying the desired shapes and textures. If you want a drybrush texture, choose a rough, hard-sized surface. If you don't want any texture, choose a hot-pressed paper with a naturally bright surface. Painting the same subject on different papers is a great exercise for getting to know the surfaces. This will force you to adapt to your materials and learn how to control them, pushing you creatively and possibly revealing something new about your subject. Sometimes it's helpful to use an unforgiving paper like hot-pressed paper, which can help break bad habits, such as lacking patience between applying washes.

Mixing Palettes with George Butler

A mixing palette is important because it's what an artist uses to prepare the paint before applying it. A palette features several wells that hold watercolor paints and washes, as well as larger areas for mixing colors. The are a wide range of available palettes, including rectangular, round, large, small, disposable, with or without a thumb hole, and so on. Experiment with your options; then choose a palette that is comfortable to you.

Plastic & Metal Palettes

White plastic palettes are lightweight, inexpensive, and readily available in a variety of sizes. The smooth plastic surface allows you to wipe them clean after each use. Because we rely on the transparency of watercolor, mixing on white is helpful for judging the color and strength of a wash before applying it to the paper. If you are working on colored paper, you might want to use a plastic palette of the same color.

Stainless steel and tin palettes (coated in white) can be great for painting in a studio, especially if you prefer a bit of weight to your mixing surface. These metal palettes last longer than their plastic counterparts; however, they are often not as portable or affordable.

Setting Up Your Palette

For the sake of familiarity and speed, place your colors in the same order on the palette each time you paint. Many artists choose to follow the spectrum. In my small white tin box of paints, I am consistent with my color placement. I find that it's easier to judge one color next to another if I am familiar with the layout. I also reserve an area on my palette for a color mix that I would like to save for another session. On my palette (left), I store my brushes in the center between two rows of paints, and I use the inside of the lids for color mixing. If I'm running low on any paint color, I simply add more from the tube into the paint well.

Unique Materials with George Butler

Once you are comfortable working with the basic watercolor tools, you should experiment with new materials and techniques, which is vital for improvement and artistic growth. Found ephemera, such as feathers or papers, can enhance your images by adding texture and giving your travel art a sense of place.

When painting in foreign countries, I often remind myself that the culture around me has probably been painting and creating for thousands of years. I like to represent this idea in my works. While traveling, I have found and used pelican feathers in Senegal, goatskins in Timbuktu, powdered dyes, and brown-paper cement bags. Markets often sell old pens, brushes, charcoal, and gum arabic. If you can't stick your ephemera on the work itself, consider using it to apply the paint!

For this ink drawing of pelicans in Senegal, I fashioned a pelican feather into a dip pen.

Whatever the tools or techniques you'd like to try, embrace their uncertainty before throwing them away in a creative rage. The most satisfactory tool I have used is a wooden coffee stir stick. I cut one end to a point for thin lines and use the flat edge to block out areas. These easy-to-find tools work brilliantly with ink, as well. I generally work with a new tool until the novelty wears off, adding my favorite aspects of working with it—a unique mark, a thinner line, or a new sense of expressiveness—to my repertoire of techniques.

Use as many different materials as necessary to help you complete your artwork. I often enjoy working with:
- Sponges
- Charcoal
- Dip pens
- Quills
- Wooden coffee stir sticks
- Mediums and masking fluid (see "Mediums," page 33)
- Blotting paper (see "Blotting," page 62)

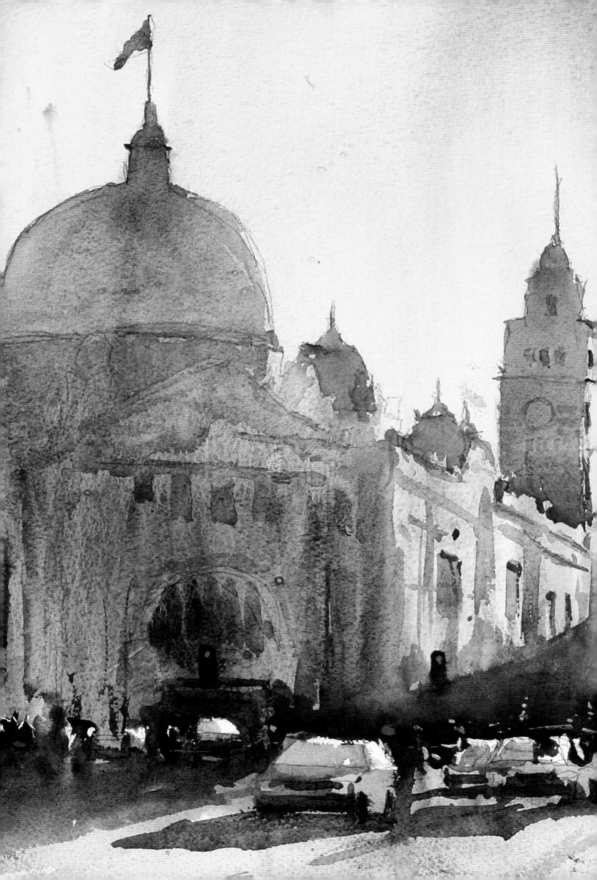

SECTION TWO

Paints

with Charles Sluga

- Understanding Pigments
- Paint Characteristics
- Opaque vs. Transparent Paint
- Understanding Color
- Color Mixing
- Color Choices

Understanding Pigments

Types of Pigments

A pigment is the substance from which a paint color is created. A pigment can be either natural organic, natural inorganic, synthetic organic, or synthetic inorganic. Organic pigments are derived from living matter or substances that were once part of living matter. Inorganic pigments do not contain carbon and are created from materials not found in living matter.

Earth Colors: These natural inorganic colors are taken from the ground and are known for their low tinting strength and high permanence. Examples include ochres, siennas, and umbers.

| raw sienna | burnt sienna | burnt umber |

Modern Colors: These synthetic organic colors are known for their clarity and transparency. They tend to have chemical-sounding names, such as phthalocyanine, quinacridone, and perylene.

| Winsor Blue (green shade) | quinacridone gold | perylene maroon |

These synthetic inorganic colors have moderate tinting strength. Cobalts, cadmiums, and ultramarines fall into this group.

| cobalt blue | cadmium yellow pale | French ultramarine |

Paint Characteristics

Unique Qualities

The idiosyncrasies of a pigment play as much a role in my choice of paint as the color itself. Below are a few characteristics of note:

Permanence: Permanence refers to a paint's ability to retain its original color over time. The staying power of pigments used today is much stronger, making this less of an issue than it was years ago.

Staining: The staining ability of a paint refers to how easily you can remove its color from the painting surface. Modern colors tend to stain more than traditional or earth colors. Some artists use a painting technique that involves lifting off paint from the surface using a dry brush or a tissue; in this case, knowing the staining power of your paint is important.

These examples show the lifting off of a staining modern color (perylene violet) versus a non-staining earth color (raw umber).

Granulation: The mottled affect of granulation is generally formed by heavy pigment particles collecting in the tooth of the paper. To many artists, including myself, granulation is a prized characteristic that adds interest to a painting. In general, the traditional and earth pigments granulate, whereas the modern pigments do not.

Four Winsor & Newton granulating colors, from left to right: cerulean blue, Potter's Pink, cobalt turquoise light, and Rose Madder genuine.

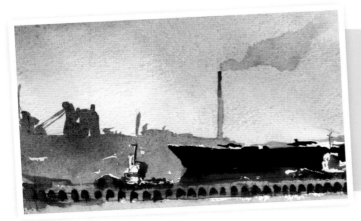

In this painting, I used granulation to add texture and weight to the industrial sky.

Opaque vs. Transparent Paint

Nothing strikes fear into the heart of an amateur watercolorist more than the mention of opaque watercolors. In fact, some avoid using them altogether. We tend to think of watercolor paintings as being transparent, but opaque accents can be very effective. It would be a shame to avoid using such wonderful colors as cadmium red or cerulean blue simply because they are opaque.

There are two myths about opaque colors that I would like to dispel. First, artists often think that opaque color mixes will produce muddy results. Mud can occur when mixing any colors, whether opaque or transparent. The more colors that are added to a mix, the more likely mud will result. Second, many artists believe that opaque colors will obscure other colors, rendering them useless as glazes; however, if you add enough water to the mix, an opaque color can act as a transparent color.

To sum it up, keep your opaque mixes fresh by adding plenty of water and limiting the number of colors you use. Know which colors are opaque and transparent in your palette, and do not let fear of opaque colors deter you from using them.

☐ Transparent

◩ Semi-Transparent

◼ Opaque

◪ Semi-Opaque

All of Winsor & Newton's watercolor paints are labeled according to their opacity, as shown above.

Artist Tip

Adding Gum Arabic to a color will increase transparency for greater luminosity in your washes. (See "Gum Arabic," page 35.)

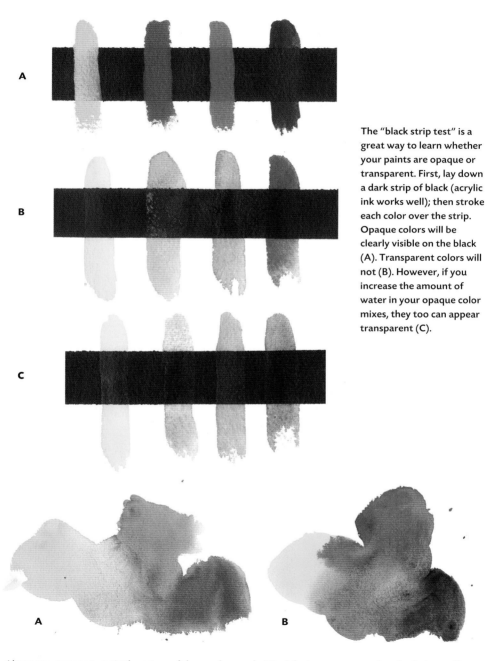

A

B

C

The "black strip test" is a great way to learn whether your paints are opaque or transparent. First, lay down a dark strip of black (acrylic ink works well); then stroke each color over the strip. Opaque colors will be clearly visible on the black (A). Transparent colors will not (B). However, if you increase the amount of water in your opaque color mixes, they too can appear transparent (C).

A

B

Above you can see two similar mixes of three colors each. Mix A features opaque colors (cadmium yellow, cadmium red, and manganese brown). Mix B features transparent colors (transparent yellow, permanent rose, and burnt umber). Although mix B is more vibrant, you can see that mix A does not produce a muddy result because I used an adequate amount of water.

Understanding Color

Color Wheel

The color wheel is a circular diagram that illustrates color relationships and aids with mixing. Many theories and versions of the color wheel have surfaced over the years, but I will simply present the most basic pigment wheel and associated terms.

Primary Colors: yellow, red, and blue

Secondary Colors: green, orange, and violet

Tertiary Colors: colors between a secondary and a primary, such as yellow-green

Complementary Colors: colors opposite each other on the wheel

Analogous Colors: colors adjacent to one another on the wheel

Color Basics

Value, temperature, and chroma are the basic visual characteristics—or dimensions—of a color. These dimensions help us describe, distinguish, and more effectively combine our colors. Each dimension is independent of the others and can change without affecting one another. Understanding these dimensions and how to manipulate them is a powerful tool in color mixing.

▶ **Diagram 1** These swatches show a variety of values, temperatures, and chromas of yellow, blue, and red.

Yellow Family

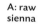

A: raw sienna B: cadmium yellow pale C: Winsor Lemon

Blue Family

D: Winsor Blue (green shade) E: French ultramarine F: cerulean blue

Red Family

G: permanent crimson H: Scarlet Lake I: burnt sienna

Value

Value refers to the lightness or darkness of a color. This characteristic plays an important role in the design of a painting; without variations in value, a painting can appear flat and uninteresting. There are two main ways to regard value as it relates to color. First, each color is inherently a different value. (For example, ultramarine is darker than cadmium yellow.) Second, each color can be represented in a range of values. You can change the value of watercolor paint simply by adding water; the more water you add, the lighter the value will become.

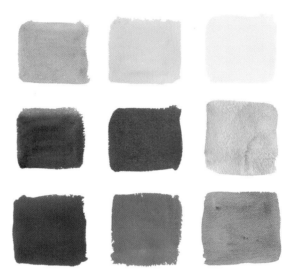

▲ **Diagram 2** This image features a grayscale photo of Diagram 1 (see opposite page), revealing the value of each color.

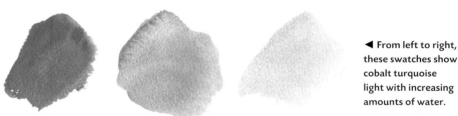

◀ From left to right, these swatches show cobalt turquoise light with increasing amounts of water.

Temperature

Colors each have a psychological association to temperature. Reds, oranges, and yellows are considered warm, as we associate them with warm things such as fire and sunshine. Blues, violets, and greens are cool colors because we associate them with water, ice, cool grass, and so on. Members of the same color family can vary in temperature as well; for example, some blues are cooler than others.

Chroma

Each paint color has a specific chroma, which refers to the intensity, richness, or saturation of the color. To grasp this concept, it may help to compare permanent crimson (G), a bright red, and burnt sienna (I), a dull red, in Diagram 1. G is of a higher chroma than I.

Color Mixing

Now you are ready to mix your paints and apply them in hopes of producing the masterpiece you envision. A key question arises: "What is the best way to mix my colors?" There are three main ways to mix, and one way is not better than the others. I often use all three methods when producing a painting, as I'm sure many artists do.

The three ways include mixing wet-into-wet on the paper, mixing in the palette, and glazing. Each produces a different effect and all have their uses, but beginners generally tend to over-mix in the palette. As in the illustrations below, the same colors mixed in three different ways produce very different results.

 A
 B
 C

Mixing in the palette (A) involves combining pigments before applying a wash to the paper. Glazing (B) involves layering separate washes of paint, allowing them to dry between applications. Wet-into-wet (C) involves blending the washes and letting the pigments intermingle on the paper's surface. (See "Basic Techniques Review," page 52.)

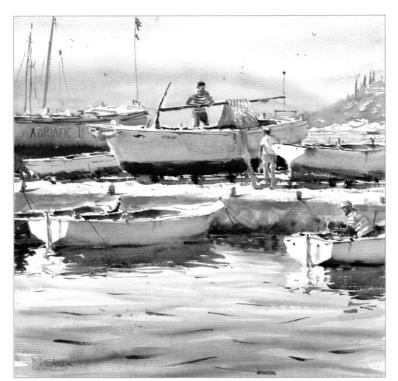

In my painting *Lazy Sunday Afternoon, Dalmatia,* I used all three methods of color mixing, adding variety and interest to the surface quality of the painting. I used wet-into-wet for the boat hulls, a glaze of violet in the foreground, and premixed colors for details and dark accents.

Mixing Greens

Most people are aware that you can mix a green by combining blue and yellow. But when you have four blues and three yellows in your palette, how do you know which to mix? A simple solution is to use temperature bias. See where your blues and yellows lie on the color wheel and then decide on the type of green you want. If you want a high-chroma green, mix the blue and yellow that are closest to each other on the color wheel. For a muted green, use the blue and yellow situated farthest from each other.

I find that a wonderful way to mix greens is to start with Winsor Green (blue shade) and manipulate it by adding other colors from my palette. This is the only green paint I have in my palette because it is so versatile. It is intense, dark, transparent, and staining—precisely the properties that make it a great starting point. It is simply a matter of changing its color dimensions to achieve your desired green. Below are some possible green mixes using the colors in my palette.

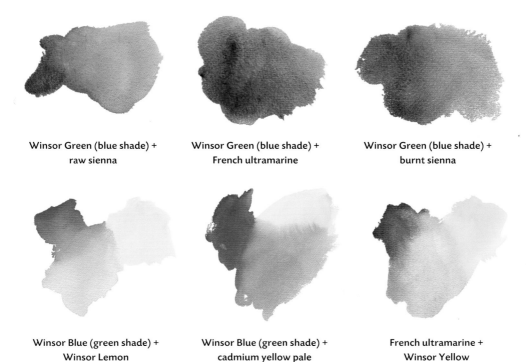

| Winsor Green (blue shade) + raw sienna | Winsor Green (blue shade) + French ultramarine | Winsor Green (blue shade) + burnt sienna |
| Winsor Blue (green shade) + Winsor Lemon | Winsor Blue (green shade) + cadmium yellow pale | French ultramarine + Winsor Yellow |

Mixing Neutrals and Blacks

One of the most useful pieces of information you can learn about color mixing is related to complementary colors. To simplify, think of complementary groups as red and green, blue and orange, and violet and yellow. A complementary color can be used to reduce a paint's chroma, thereby neutralizing the color. For example, adding a bit of blue to orange reduces the chroma of the orange. Mixing larger amounts of a complementary color into the original results in a *neutral*—a brown or gray color. Use this same method to mix blacks; simply use less water.

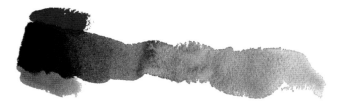

This rich neutral mix is made up of French ultramarine and burnt umber (from the blue and orange complementary group).

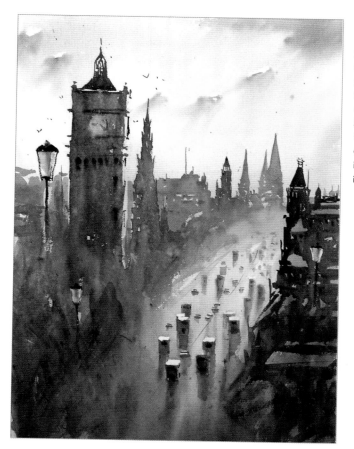

You may wonder why I don't suggest purchasing a gray or black tube of paint. Neutralizing colors to make your own grays and blacks offers a richer and larger range of options. In *Princess Street Edinburgh*, I mixed my own neutrals, which allowed me to create a predominantly neutral image that is still lively and interesting.

Color Choices

All artists develop a personal palette of colors. Although they may swap or add colors over time, the core of the selection often remains the same. If you're a beginner, I suggest that you start with a small selection of colors and build as you progress.

A good beginner's palette might consist of Winsor Lemon, Winsor Yellow, French ultramarine, Winsor Blue (green shade), permanent rose, and Scarlet Lake. I feel that this selection provides colors that are flexible and useful for mixing a larger range of colors. Another great palette selection for beginners includes French ultramarine, Winsor Green (blue shade), permanent alizarin crimson, burnt sienna, raw sienna, and cadmium yellow pale. Whatever palette of colors you choose, I suggest beginning with about six colors; once you have a feel for how they behave individually and in mixtures, feel free to expand.

I have 18 colors in my palette (below) and find that they suffice for anything I need to paint.

A.
B.
C.
D.
E.

A. French ultramarine: a warm blue that granulates

B. Cobalt blue: a velvety middle blue

C. Cerulean blue: a soft, cool blue that granulates

D. Winsor Blue (green shade): a rich, cool blue; great for mixing vibrant darks

E. Winsor Green (blue shade): a vibrant dark green; useful for mixing other greens

F. Cadmium yellow pale: a warm yellow; great for color accents and mixing oranges

G. Winsor yellow deep: an egg yolk color; useful for warm glazes

H. Raw sienna: an earth color that I use frequently

I. Raw umber: a soft earth color; useful for mixing subtle grays

J. Burnt umber: a deep earth color; great for darks and neutral grays

K. Burnt sienna: a very versatile burnt earth color; great for grays and adding warmth

L. Cadmium scarlet: a warm opaque color; useful for color accents and warm washes

M. Winsor Red: a beautiful middle red used to mix beautiful purples

N. Permanent alizarin crimson: a deep staining color; great for mixing darks and purples

O. Perylene maroon: good for mixing softer purples

P. Winsor Violet: a vibrant violet used for dark accents

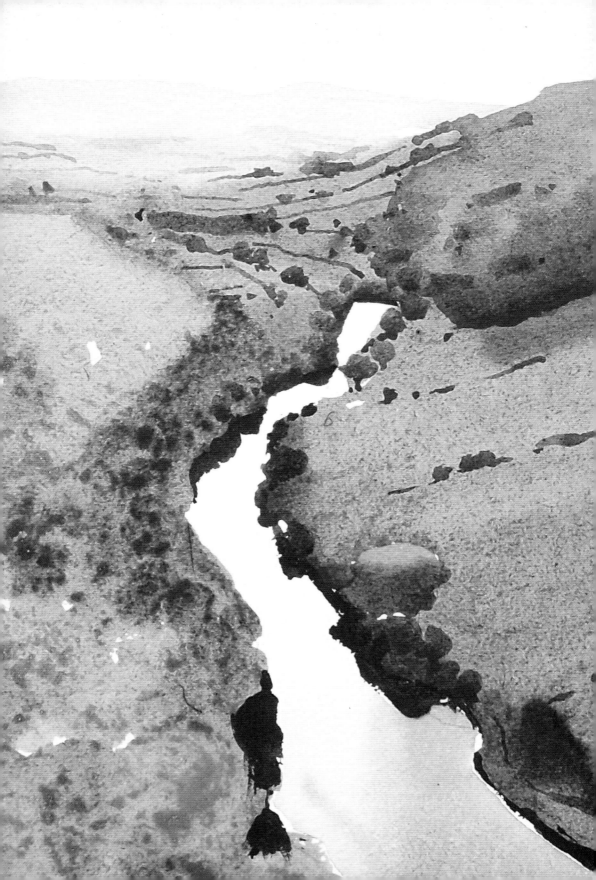

SECTION THREE

Mediums

with Nick Poullis

- Introduction to Mediums
- Gum Arabic
- Masking Mediums
- Blending Medium
- Granulation Medium
- Lifting Preparation Medium
- Ox Gall Liquid
- Texture Medium
- Iridescent Medium

Introduction to Mediums

A medium is an additive that affects the character of the paint. Generally, artists use mediums to achieve a level of control not available in pure watercolor painting. Mediums can change the body or texture of the paint, create a glossy or matte sheen, reduce drying time, encourage blending, or even retain the white of the paper. Artists have used mediums since the early days of watercolor—a few mediums, such as gum arabic and ox gall, are as old as watercolor itself. Some mediums, such as masking fluid, replace or improve upon older mediums, while others are modern developments, such as granulation medium. Finally, some mediums simply amplify the natural tendencies of pure watercolor paint.

I prefer Winsor & Newton mediums for their superior quality and the results they produce in my artwork. Like any effect in painting, however, mediums are best used judiciously. Avoid overusing them or allowing the particular effect to become the subject of the work itself. Instead, the medium should produce results that enhance your subject. Mediums are certainly not a substitute for good painting, and you must always respect the essential character of watercolor to retain freshness and luminosity in your work. Thus, it is necessary to understand mediums properly and learn to effectively combine them with traditional use of watercolor. On the following pages, you will find more detail about a few select mediums, as well as information for using each one. Experiment with these tools and others as you develop your style and techniques.

Frank Antiques by Nick Poullis, 22" (w) x 15" (h). Watercolor with Gum Arabic medium.

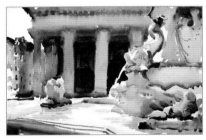

Pantheon and Fountain by Nick Poullis, 22" (w) x 15" (h). Watercolor with Masking Fluid medium.

Winsor & Newton Mediums

- Art Masking Fluid
- Aquapasto
- Blending Medium
- Colourless Art Masking Fluid
- Granulation Medium
- Gum Arabic
- Iridescent Medium
- Lifting Preparation
- Ox Gall Liquid
- Permanent Masking Medium
- Texture Medium

Gum Arabic

A natural gum obtained from the Acacia tree, gum arabic is the binder used in all watercolor paints. When using it as a medium, you are essentially adding to what is already present. Gum arabic helps the paint sit on the surface of the paper, fixing the pigment so you can create crisp edges. It also aids in luminosity and prevents the pigment from lightening upon drying. Used in small doses, gum arabic slows the drying time of paint, increasing the amount of time you can work on a painting. While working wet-into-wet, the medium adds further transparency to the paint and increases gloss. Usually artists mix gum arabic into a watercolor wash, but you can add it to your mixing water if you'd like to use the medium throughout the entire painting. Avoid applying it directly to your painting, however. As a layer on paper, the medium will become brittle and crack.

Gum Arabic Medium Demonstration: *Pezenas*

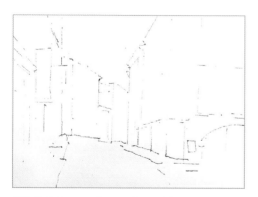

STAGE 1 I create the initial pencil drawing, outlining the main compositional elements.

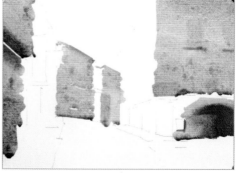

STAGE 2 I add a liberal dose of gum arabic to my mixing water to give the paint a glossy finish and glow. I add large areas of wet-into-wet and graduated wash.

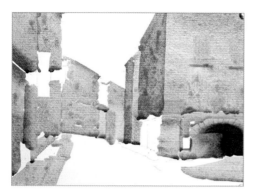

STAGE 3 I add a few details, refining some of the shapes in the wet-into-wet wash. It is important to let each layer of paint dry properly before adding the next.

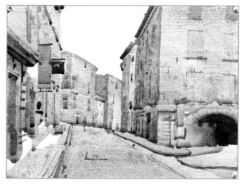

FINAL STAGE I finish the painting by adding further details and figures for a sense of scale.

Masking Mediums

Masking out is an important watercolor technique that involves preserving the white of the paper, protecting it from subsequent layers or droplets of paint. It is most often used to preserve details that could easily disappear under washes during the painting process, such as highlights or lettering on a shop front. You can also use the medium more broadly to preserve important shapes within the design of your painting, as in the demonstration on the opposite page. To apply a masking medium, use a fine brush and simply paint it on the paper. Once the medium is dry, you can paint freely. Winsor & Newton offers three different masking mediums.

Permanent Masking Medium

If you wish to retain the white of the paper permanently, opt for Permanent Masking Medium. Once applied, this waxy substance cannot be removed. You can either apply it directly to the paper or mix it with your watercolors.

▲ Example of a wash applied over Permanent Masking Medium.

Art Masking Fluid

Art Masking Fluid is a pale yellow latex resist that you can rub off after a painting has dried. This medium is best paired with a hard-sized paper to avoid damage from rubbing.

Colourless Art Masking Fluid

Colourless Art Masking Fluid is a clear liquid that you can apply over a layer of paint, protecting it from subsequent layers.

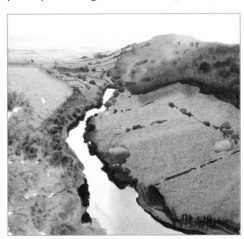

▲ In this painting of Wye Valley in South Wales, I kept the river clean and its edges crisp using Winsor & Newton's Colourless Art Masking Fluid.

Artist Tip

Art Masking Fluid has a slight yellow tinge, which makes it easier to see where it has been applied. When using soft paper, use Winsor & Newton's Colourless Art Masking Fluid to prevent staining.

Masking Fluid Demonstration: *Mill at Beziers*

STAGE 1 After creating a careful drawing, I use Art Masking Fluid to define some shapes of the reflected mill in the rippled water. I wash the brush immediately and wait for the medium to dry.

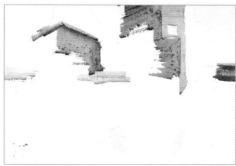

STAGE 2 Now I apply some of the lights; once dry, I follow up with darker shapes.

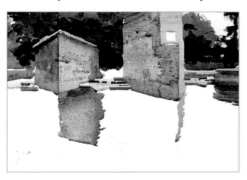

STAGE 3 To help define the mill in distance, I add a dark background of trees. Then I create some reflections.

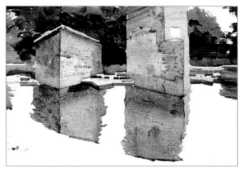

STAGE 4 I continue adding reflections and darker shapes to define the features.

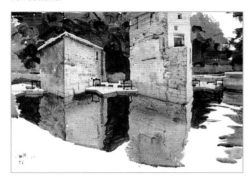

STAGE 5 Now I paint the water, stroking directly over the masked areas. I allow the paint to dry completely.

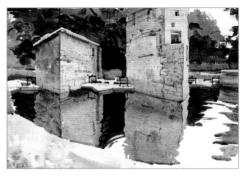

FINAL STAGE I build up detail in the foreground and rub to remove the masking.

Blending Medium

Beautiful, fluid blends are a highly valued aspect of watercolor painting. Achieving successful blends is often a time-sensitive challenge, especially in hot and dry atmospheric conditions, which can accelerate a paint's drying time. Blending Medium slows the drying time of your paint, allowing you to work longer with wet, blendable washes. You can use Blending Medium in two main ways. For maximum blending time, mix it directly with the paint before applying it to the paper. For a more subtle effect, apply the medium directly to the paper just before applying watercolor. In either case, once the watercolor wash is dry, you can apply subsequent layers as usual.

Winsor & Newton's Blending Medium extends the paint's drying time, allowing for the creation of beautiful, blendable washes. When dry, additional washes can be applied over previous washes containing Blending Medium.

Blending Medium Demonstration:
Bright Morning Pezenas

STAGE 1 After creating a quick sketch on site, I add Blending Medium to my mixing water and paint a few lights.

STAGE 2 Once the previous layers dry, I gradually block in more shapes.

Artist Tip

Watercolor dries quickly, especially when working on site. In addition to using Blending Medium to extend dry time, it helps to work in the shade and at a slightly smaller scale, such as 10" x 12".

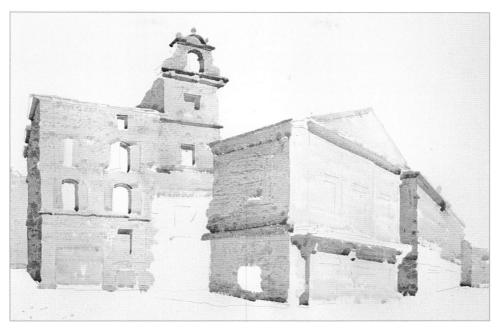

STAGE 3 I continue defining the forms of the building. The medium keeps my washes wet while I add reflections and color variations in the shadows.

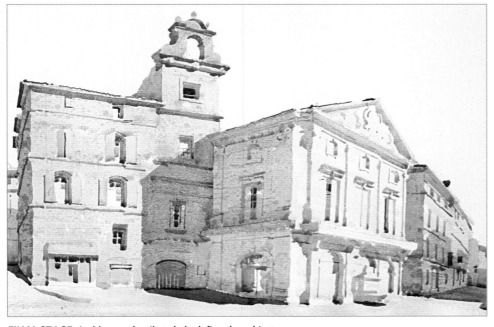

FINAL STAGE I add more details to help define the subject.

Granulation Medium

Granulation is an effect that occurs when two or more select pigments mix and react to produce a mottled, grainy result. Because not all pigments react this way naturally, you can use Granulation Medium to fabricate the effect in smooth washes of paint, creating texture within otherwise flat areas. Granulation Medium does not diminish the luminosity or freshness of the paint. Although the medium is resoluble when you re-wet the surface, the paint will remain intact when details are added over a dry layer.

Normal Winsor Blue (red shade) Wash.

Winsor Blue (red shade) mixed with Granulation Medium.

There are several ways to maximize or minimize the effects of this medium. Generally, the more medium you mix into the watercolor, the more intense the effect. For dramatic results, you may dilute your watercolor with medium alone or add it to pigments that already granulate.

▲ You can achieve a variety of effects with Granulation Medium, depending on how much you use, your paper surface, and if you dilute the mixture with water. Experiment to see what work best for you.

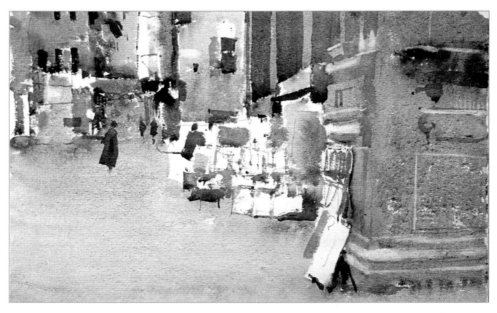

In *Florence Gazzeto*, granulation medium adds to the rough quality of the image and plays into the texture of the stone wall.

Granulation Medium Demonstration: *Pezenas Alley*

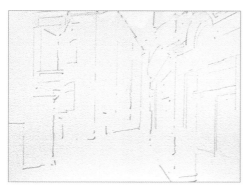

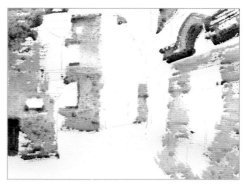

STAGE 1 I deliberately choose a stony subject that will benefit from a granular effect. To beef up the texture, I also choose to work on a rough, 140 lb hard-sized paper. I begin sketching the scene.

STAGE 2 I add a liberal amount of Granulation Medium to a pool of paint on my palette and wait for the granulation to start. Using a #8 round brush, I loosely apply the paint to the largest shapes. I also drop in some rich color and define a few edges.

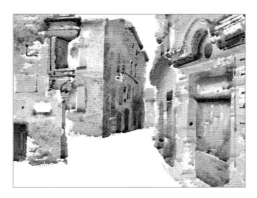

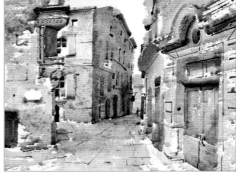

STAGE 3 I further define the larger shapes using the #8 brush. While applying the paint with a very "wet" approach, I see the mottled effects appearing in the shadows.

FINAL STAGE For smaller details and lines, I switch to a small rigger (fine line) brush. I add a figure to give scale to the scene. I do not use the medium when creating the fine details, as its effects are evident only in larger areas.

Artist Tip

Painting surfaces affect granulation. For maximum granulation, use rough paper; for less granulation, use cold-pressed paper. (See "Watercolor Paper," page 14.)

Lifting Preparation Medium

Lifting Preparation Medium allows you to lift off dry washes, including staining pigments, from your painting surface. You can use this medium to remove unwanted marks, as well as leave white marks within your washes. Simply prime your paper with a layer of undiluted Lifting Preparation and let it dry. Next, paint the surface as you would normally, and allow to dry. Finally, use a moist paintbrush to gently stroke or rub off the paint in the desired areas, lifting it away from the surface with a tissue or other absorbent material. This technique is useful for creating sharp edges and details that contrast nicely with surrounding washes. The medium allows you to work with a free and loose approach from the start, instead of painting tightly around these white areas. I find it best to reserve lifting for the final stages of the painting process.

▲ Winsor & Newton's Lifting Preparation Medium allows you to lift away the pigment using thick, thin, soft, or crisp strokes for a range of effects.

Artist Tip
To remove paint from larger areas, use a damp sponge instead of a paintbrush.

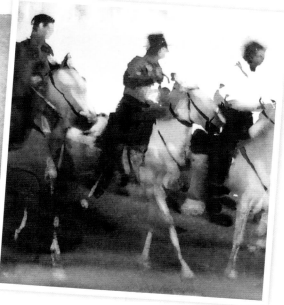

▲ Lifting Preparation Medium allows me to softly pull out and define the horses' legs in *Les Gardiens*.

Lifting Preparation Medium Demonstration:
Tour de France Cyclists

STAGE 1 Using a #8 round brush, I apply a layer of Lifting Preparation Medium to the paper. Once dry, I use a very wet approach to block in the main shapes of the composition with a wet-into-wet wash, keeping it loose and full of movement.

STAGE 2 Still using a round #8 brush, I apply graduated washes to the background forms. Where these washes meet the previous layer, outlines begin defining the forms of the cyclists.

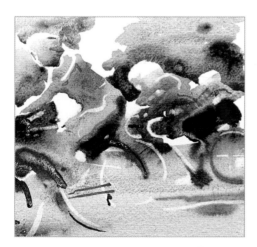

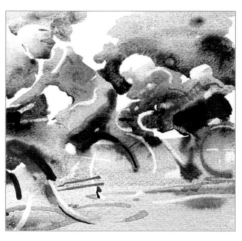

STAGE 3 Once completely dry, I begin lifting with a #7 round brush. I rub a bit of water on these areas and lift from small areas with tissue paper.

FINAL STAGE I apply further touches of paint to define some shapes, but I avoid overworking the painting to maintain the sense of movement.

Ox Gall Liquid

Ox Gall Liquid is a wetting agent that improves the flow of watercolors. The medium has been used for hundreds of years and is made of bile extracted from cows and mixed with alcohol, which gives it a foul smell. The mixture acts as an emulsifying agent that breaks down the paper's resistance to water, making it easier to apply washes without beads of paint skipping over the surface. The medium is colorless, has no effect on the way paint mixes, and has no long-term detrimental effects on the artwork. It is most effective when using hard-sized watercolor paper.

To use this medium, simply add a few drops of the liquid to your mixing water. A small amount of Ox Gall can result in a very lively surface, so experiment with varying amounts. The more medium you add, the wetter the wash will be. With a large dose of Ox Gall, the wash will be accepted immediately and with no resistance; this is extremely useful when laying down a large area of flat or graduated wash, which can sometimes go wrong when a painting surface does not readily accept the paint.

Depending on your subject, you may want to limit use of the Ox Gall to the areas that call for less resistance. Applying a covering wash that includes the medium takes away resistance of the surface, so any subsequent detail or wash goes on with little or no resistance, as well; however, on hard-sized paper, you may be able to recover some of the resistance. In *View Over Montagnac* (above right), I used a very small dose of Ox Gall in the first wash and applied it sparingly using an almost drybrush technique across the surface. Once dry, you can add another layer and benefit from the resistance.

In *View Over Montagnac*, I combined areas of resistance with areas of no resistance. Note how the loose, wet sky contrasts nicely with the sharp shadows and edges of the architecture.

Regular wash on hard-sized paper.

Wash applied after Ox Gall layer.

Ox Gall Liquid Demonstration: *Boats Sete*

STAGE 1 I create the initial drawing using a 2B pencil and avoid erasing because it can damage the paper surface.

STAGE 2 I add a few drops of Ox Gall to the water. Now I apply the largest area of paint—the background sky—as well as the lights of the buildings. Working light to dark helps me keep the painting organized.

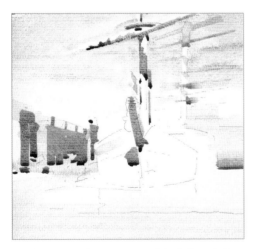

STAGE 3 Now I bring in some of the lighter darks on the building and ship, adding further details.

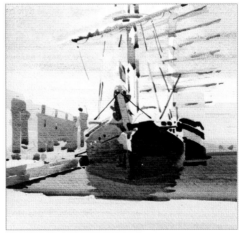

FINAL STAGE To finish the painting, I apply the darkest, richest areas of color. I add details to create interest and define shapes.

Texture Medium

Texture Medium acts in two ways. First, it gives the paint more body, altering the way it lays on the paper. Second, as the name suggests, it makes the surface coarse and grainy to the touch. Because Texture Medium contains fine particles, it can be used to add depth and structure to watercolor paintings. You can apply Texture Medium directly to the watercolor paper, or you can mix it with the paint before applying. Texture Medium is resoluble, so it will mix with subsequent layers, although some of the initial color will remain on the paper.

▲ The fine particles in this medium add texture that can be used to create dimension and structure.

◄ In the first example (far left), notice how even one layer of Texture Medium can add interest. The second example (near left) shows how Texture Medium is used in multiple washes, capturing different layers of color for added depth.

Artist Tip

Texture Medium is especially useful for painting close-ups to emphasize an object's texture.

Texture Medium Demonstration: *Beziers*

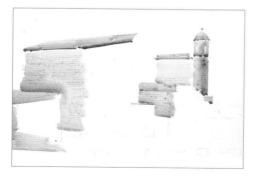 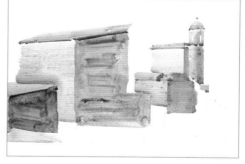

STAGE 1 I begin by painting the lightest areas over a simple drawing.

STAGE 2 I add a good dose of Texture Medium directly to my palette and mix it with the paint, dramatically altering the consistency. I restrict its use to the darks of the structures.

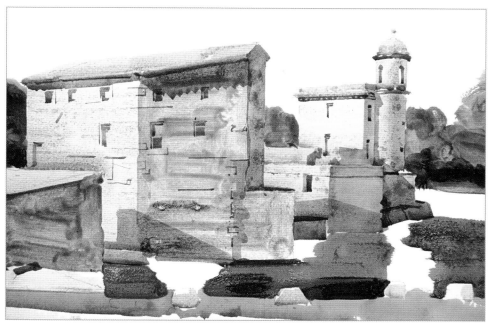

STAGE 3 Now I add background elements and suggest the windows with small strokes. I apply a second layer of paint over the textured areas, taking care not to dissolve the Texture Medium.

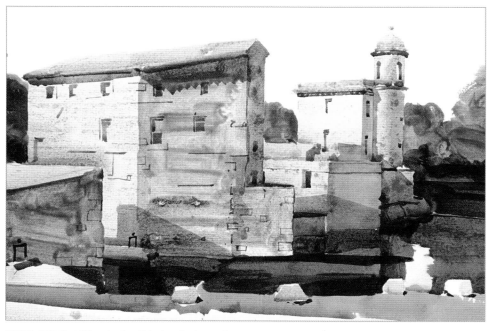

FINAL STAGE I fill in the final blocks of color and suggest a few bricks with fine brushstrokes.

Iridescent Medium

Iridescent medium gives watercolor a pearlescent sheen, or shimmering effect. You can either mix the medium with your paints directly or apply it as a layer over a dry wash. Iridescent medium is particularly effective when mixed with transparent colors, which allow the light of the paper to illuminate the paint. The medium has a decorative effect that is useful for crafts like greeting cards and paper sculptures, but you can also use it effectively in realistic painting when the subject allows. Iridescence does occur naturally in some insects and birds. For the demonstration below, I found the common duck to be an appropriate subject.

▲ Iridescent Medium is especially effective when used over a dark background.

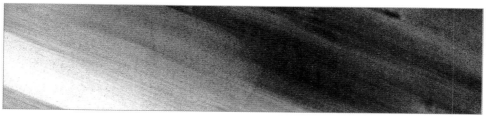

Winsor & Newton's Iridescent Medium adds shimmer to watercolor. You can mix it with paint or apply the medium over a dry wash.

Iridescent Medium Demonstration: *Mallard*

STAGE 1 I lay in a few large, simple shapes using muted colors, which will contrast well with the iridescent layers I lay down in Stage 3.

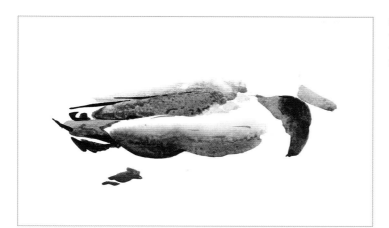

STAGE 2 Now I add the dark chest and tail feathers. I suggest the beak with one stroke.

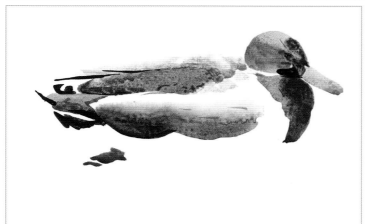

STAGE 3 I add the green head and facial markings. Then I apply Iridescent Medium along the duck's back to capture the effect of light on the feathers.

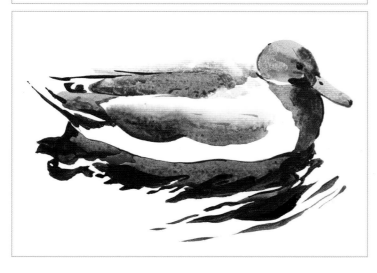

STAGE 4 I add Iridescent Medium with viridian and apply it to the head. Then I complete the water by adding dark ripples.

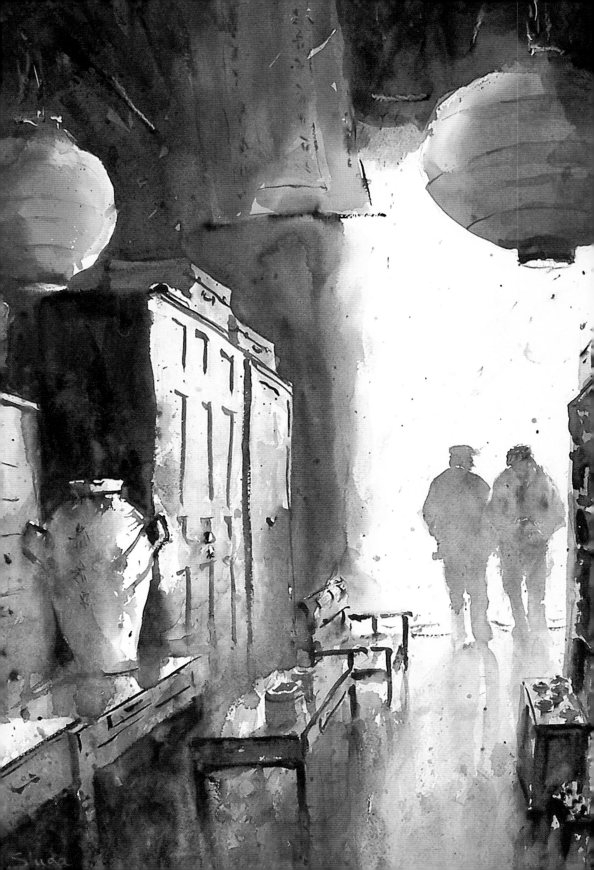

SECTION FOUR

Gallery
of
Techniques

- Basic Techniques Review
- Controlled Layering
- Wet-into-Wet
- Drybrush
- Thick-on-Thin
- Graduated Wash
- Emphasizing with Color
- Blotting
- Dripping & Flicking

Basic Techniques Review

Below is a quick review of some ways you can apply and manipulate watercolor paint.

Flat Wash Cover your paper with horizontal bands of even color, starting at the top and working your way down.

Graduated Wash Load your brush and apply overlapping strokes, adding water with each consecutive stroke. The color will gradually thin out as you continue.

Artist Tip

A graduated wash can also move from one color to another. Instead of adding water, stroke in a different wash. This will create a subtle transition between colors.

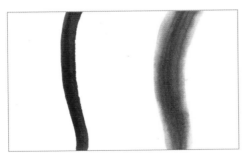

Soft and Hard Lines For a hard line, paint a dry stroke on dry paper. Any line can be softened by blending the edge with clear water before it dries.

Stippling Stippling involves applying paint with dots or light touches of the brush. This technique adds texture and interest.

Glazing

Glazing involves two or more washes of color applied in layers to create a luminous, atmospheric effect. Glazing unifies the painting by providing an overall underpainting (or background wash) of consistent color. (See "Color Mixing," page 28.)

Creating a Glaze To practice creating a glazed wash, paint a layer of ultramarine blue on your paper (near right). Your paper can either be wet or dry. After this wash dries, apply a wash of alizarin crimson over it (far right). The subtly mottled purple that results is made up of individual glazes of transparent color.

Wet-on-Dry

This method involves applying different washes of color on dry watercolor paper and allowing the colors to intermingle, creating interesting edges and blends.

Mixing in the Palette vs. Mixing Wet-on-Dry To experience the difference between mixing in the palette and mixing on the paper, create two purple shadow samples. Mix ultramarine blue and alizarin crimson in your palette until you get a rich purple; then paint a swatch on dry watercolor paper (above left). Next paint a swatch of ultramarine blue on dry watercolor paper. While this is still wet, add alizarin crimson to the lower part of the blue wash, and watch the colors connect and blend (above right). Compare the two swatches. The second one (above right) is more exciting. It uses the same paints, but it has the added energy of the colors mixing and moving on the paper.

Variegated Wash

A variegated wash differs from the wet-on-dry technique in that wet washes of color are applied to wet paper instead of dry paper. The results are similar, but using wet paper creates a smoother blend of color. Using clear water, stroke over the area you want to paint and let it begin to dry. When it is just damp, add washes of color and watch them mix, tilting your paper slightly to encourage the process.

Applying a Variegated Wash After applying clear water to your paper, stroke on a wash of ultramarine blue (near right). Immediately add some alizarin crimson to the wash (center right), and then tilt to blend the colors further (far right). Compare this with your wet-on-dry purple shadow to see the subtle differences caused by the initial wash of water on the paper.

Wet-into-Wet

To paint wet-into-wet, the paper must be thoroughly soaked with water before applying color. The saturated paper allows the color to spread quickly, easily, and softly across the paper, creating delicate, feathery blends. Begin by generously stroking clear water over the area you want to paint. Wait for the water to soak in. Apply another layer of water. When the surface takes on a matte sheen, apply washes of color and watch the colors spread. (See "Color Mixing," page 28.)

Wet-into-Wet To practice painting wet-into-wet, apply ultramarine blue to your paper, both to the wet and dry areas. Next, add a different blue, such as cobalt or cerulean, and leave some paper areas white (far left). Now add raw sienna (center left), followed by a touch of alizarin crimson (near left). The wet areas of the paper will yield smooth, blended, light washes, while the dry areas will allow for a darker, hard-edged expression of paint.

Controlled Layering with Karen Kluglein

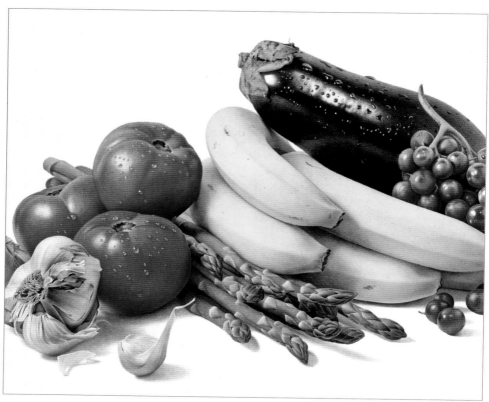

Fruit and Vegetables by **Karen Kluglein**, 17" (w) x 9" (h).

When we think of the traditional use of watercolor, we imagine colors swirling together in wet washes. This is not how I use watercolor. I begin with a controlled wash followed by several layers of parallel lines, crosshatching, or dots without disturbing the paint beneath. I apply the paint using increasingly smaller brushes, allowing each layer to dry before applying the next. It is a tedious and time-consuming process of weaving color, but the realistic results are well worth the effort.

Because I often paint life-sized botanicals and still lifes, I usually work in very small areas. I might begin building layers with a #2 brush and end with an even smaller #000 as I become more and more detailed. For all of my paintings, I use Winsor & Newton Series 7 Kolinsky Sable brushes and Winsor & Newton Artists' Water Colour paints.

Color Palette

Green gold

Hooker's green

Naples yellow

Neutral tint

Permanent magenta

Scarlet Lake

Winsor Lemon

Artist Tip

Hot-pressed, smooth paper works well for paintings that feature a lot of minute detail.

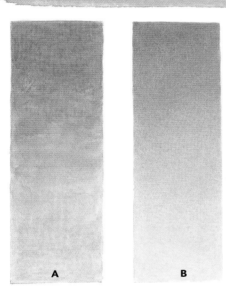

The painted strip above left (A) shows a gradation created by one simple wash of paint. Note the uneven quality. The painted strip above right (B) shows a gradation created with small lines of a drier brush, which I've carefully layered for an exceptionally smooth effect.

As I work from light to dark, I build up the layers slowly while decreasing the size of my brush. You can see that the darkest layer of strokes has been applied with a very fine brush.

Once you've mastered the art of building form through layering, you can apply it to any object for realistic results.

Wet-into-Wet with Charles Sluga

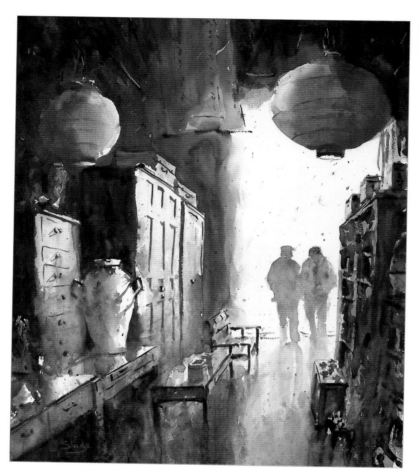

Red Ramia
by Charles Sluga,
24" (w) x 28.5" (h).

There is no better way to showcase this medium's beautiful flowing properties than working wet-into-wet. The technique involves wetting the paper evenly (until it takes on a matte sheen) and applying various washes of paint to the surface. The colors will diffuse across the wet paper, creating feathery soft blends. It is a wonderful way to connect shapes and create mood and atmosphere, as in *Red Ramia*. I painted this piece using Winsor & Newton's Series 7 Kolinsky Sable brushes (#6 and #10), mop brushes (#6 and #12), and a rigger.

Color Palette

Burnt umber

Cadmium red

Cadmium yellow pale

Cobalt blue

Permanent alizarin crimson

Winsor Violet

Wet-into-Wet Demonstration: *Flinders Street–Melbourne*

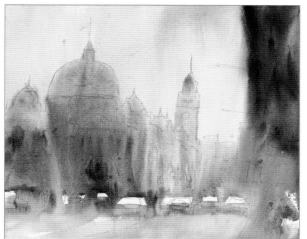

STAGE 1 To understand the wet-into-wet technique, imagine that the first stage yields an out-of-focus version of your painting. This first layer is simply a blended wash of general colors and values. Begin by wetting your paper with an even coat of water, letting it soak into the surface. Then apply your washes of color with courage, using paint of varying viscosity to achieve a range of values. Allow the colors to run and bleed beyond the lines of your sketch.

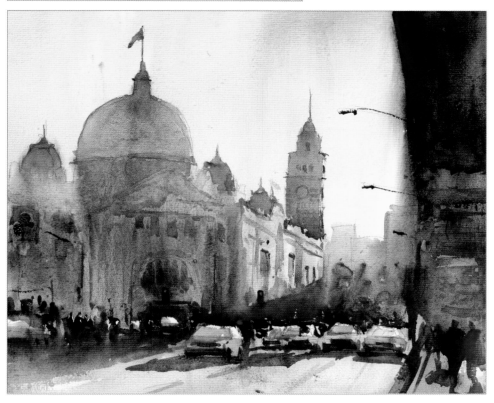

STAGE 2 After the first layer dries, decide which areas should be left untouched and which should be developed. In this stage, you are essentially re-establishing the major values, sharpening up edges, and adding details. Keep the painting loose and avoid over-painting, which can defeat the purpose of the wet-into-wet wash.

Drybrush with Nick Poullis

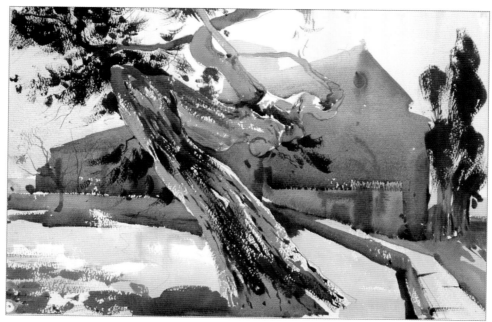

Conas by Nick Poullis, 22" (w) x 15" (h).

This subject contains elements typical to the south of France, where the light is often fierce, and pine trees, vines, and olive trees dominate the landscape. Although beautiful, pines can be challenging to capture in watercolor due to their thin, spiky needles. Drybrushing produces coarse strokes that are perfect for suggesting clumps of needles, along with the rough texture of the trunk. To perform this technique, load a paintbrush with thick paint and gently wipe the bristles to remove some of the moisture. As you stroke, the bristles will scrape along the paper surface and catch on the tooth of the paper for a textured look. For this reason, the drybrush technique works best on rough paper. To create this painting, I used Winsor & Newton's Series 7 Kolinsky Sable brushes (#5, #7, and #8) and a large squirrel-haired brush.

Color Palette

Burnt sienna

Cadmium red

Cadmium yellow

Cobalt blue

French ultramarine

Raw sienna

Viridian

Thick-on-Thin with Nick Poullis

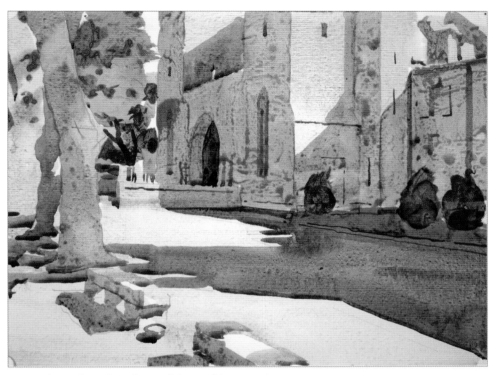

Abbey Valmagne by Nick Poullis, 12" (w) x 10" (h).

This scene at Abbey Valmagne is perfect for exploring light and atmosphere, as the cool trees contrast nicely with the warm stone and provide interesting shadows. Although usually associated with oil painting, the thick-on-thin technique can be very exciting in watercolor. The thick areas, which should be used sporadically, provide a dynamic contrast in body to the thinner washes. To enhance the contrast in paint body, I recommend working on a luminous hard-pressed surface. In this painting, I mixed the lights of the trees very thinly and added the darks using thick, visible brushstrokes for an expressive touch. I painted this on 140 lb, cold-pressed paper using Winsor & Newton's Series 7 Kolinsky Sable brushes (#5, #7, and #8) and a large squirrel-haired brush.

Color Palette

Cadmium red

Cadmium yellow

Colbalt blue

French ultramarine

Indian red

Potter's Pink

Raw sienna

Viridian

Graduated Wash with Nick Poullis

Sete by Nick Poullis, 22" (w) x 15" (h).

A graduated wash moves softly from one color into a lighter shade or a different color. Most commonly, artists use graduated washes when painting skies, moving from dark to light toward the horizon, or from blue into pink, orange, and yellow to represent a sunset. A graduated wash, however, can be used to cover a large area of the paper for the purpose of linking shapes and forms for unity within a scene. For the port of Sete on the Mediterranean coast, I used a graduated wash to simply define the distant land and pulled it down into the buildings, linking the distance to the middle ground. For this piece, I used Winsor & Newton's Series 7 Kolinsky Sable brushes, as well as Ox Gall Liquid to add greater flow to my paint.

Color Palette

Cadmium red

Cadmium yellow

Colbalt blue

French ultramarine

Indian red

Potter's Pink

Raw sienna

Viridian

Some of my paintings appear to be blotted with sporadic washes of color. My reasons for employing this style are both aesthetic and practical. Location drawing—or more specifically, *reportage illustration*—requires the artist to compete with photography, film, and the written word as a means of communicating. As the artist, you must transcend a photorealistic approach and interpret a scene as you perceive it. By applying limited color, you can emphasize areas of the painting to tell a story while leaving less important parts to the imagination. Filling in all the areas with color risks distracting the viewer from the most meaningful parts of the piece. Working on location can be difficult to manage in certain conditions. Weather, crowds, and movement are just a few obstacles that can limit the time you have to capture a scene. Punctuating a drawing with select areas of color allows you to work quickly.

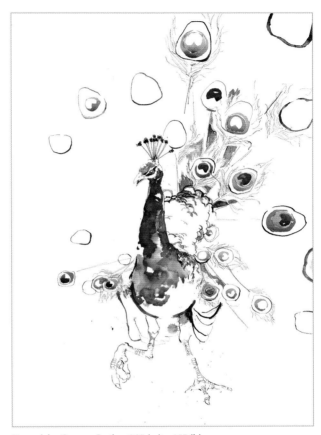

Peacock **by George Butler, 30" (w) x 45" (h).**

Color Palette

Cobalt blue

Prussian blue

Winsor emerald

Yellow ochre

Blotting with George Butler

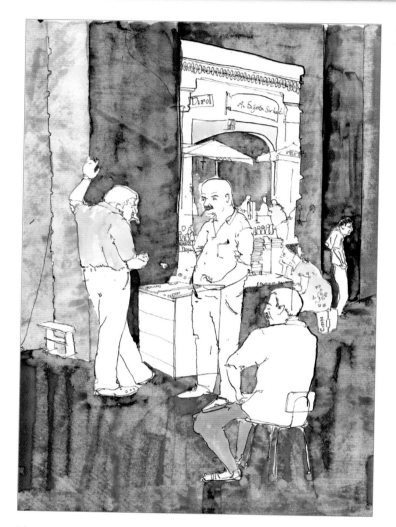

Backgammon
by George Butler,
16" (w) x 24" (h).

Blotting paper is a brilliant tool for creating interest and texture within large areas of color that would otherwise appear flat on the paper. First, apply a wash to the painting surface and leave it for a few seconds. Before it dries, press the blotting paper over the wash and lift. The mottled texture it leaves behind will vary depending on the weight of the blotting paper and the grain of your paper surface. The darker the wash, the more dramatic the result will be. You can also try this technique using cloth, tissues (free of de-bossed patterns), and other absorbent materials.

Color Palette

Ivory black

Raw sienna

Dripping & Flicking with George Butler

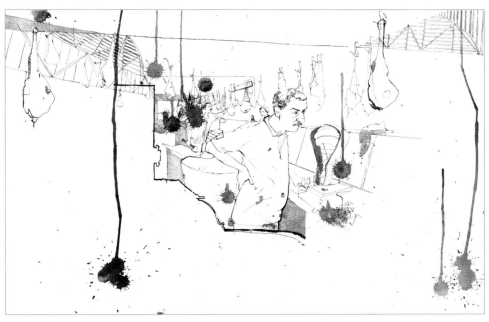

Meat Market by George Butler, 32" (w) x 24" (h).

I often accent my work with bright blotches of color and *flicking* (also called *spattering*). While also adding interest and texture to the piece, this technique is great for directing the viewer's attention to a particular area. Simply flick or drip ink onto your paper using a color that complements the rest of the work. You can do this by tapping a loaded paintbrush over your paper. To guide the drips, as in *Meat Market,* turn the paper upside down and let the paint roll across the surface of the paper.

This technique calls for you to confidently "lose control." It takes courage to drip and flick, as you don't know exactly what the image will look like. More often than not, the result will be satisfying. In all of my years of painting, I've created some of my better works while experimenting.

Color Palette

Cadmium red deep

Cobalt blue

Raw umber

About the Artists

Nick Poullis

Nicholas Poullis was born in Henley-on-Thames, England, and currently lives with his family in the south of France. After becoming a painter at an early age, he earned a B.A. in illustration. He is a previous winner of the Baker Tilly Award at the Royal Watercolour Society and has exhibited as a Winsor & Newton Finalist at the Royal Institute of Painters in Watercolours. His work is in public and private collections around the world. Nick has traveled extensively and always works from life. His watercolors have developed through his interest in exploring different regions. Nick has authored numerous articles on watercolor painting for *The Artist* magazine. Visit www.nickpoullis.com.

George Butler

George Butler was born in England and currently lives in the London area of Homerton. After finishing his B.A. in illustration at Kingston University, George spent two weeks drawing the British and American armies in Afghanistan. This experience cemented his interest in reportage illustration. All of his drawing is done on site, which creates a unique understanding of the subject that comes through in his images. George has exhibited with the Royal Institute of Painters in Watercolours since 2009, where he has won the June Roberts Stokes Bursary twice and the Winsor & Newton Young Artists Award. He has also held solo exhibitions in Dover Street and Portland Place, London. Visit www.georgebutler.org.

Karen Kluglein

Karen Kluglein resides in East Hampton, New York, and holds a B.A. from the School of Visual Arts. Following several years as a successful illustrator, Karen now paints with watercolor on calfskin vellum as she meticulously renders natural specimens in their various stages of growth. Karen was recently awarded the Dianne Boucher Award for Excellence in Botanical Art at the American Society of Botanical Artists International exhibition. Her work is in the Historical Library at the New York Botanical Garden and is exhibited and collected throughout the country. Watercolor has long been her chosen medium, with Winsor & Newton as her chosen brand. Visit www.botanical-paintings.com.

Charles Sluga

Charles Sluga is an internationally recognized watercolorist from Australia. Highly regarded for his unique vision and versatility in the medium, Charles pushes the boundaries of composition and technique to achieve his desired results. His subject matter can move from the subtle and evocative to the dramatic and bold, but it is always personal. Variety is the hallmark of his work, which he considers essential to his development as an artist. Charles conducts workshops worldwide and has been featured in several watercolor magazines. He has demonstrated the Winsor & Newton range of paints at a number of workshop venues and was one of the few artists to be featured in the Winsor & Newton catalog. Visit www.sluga.com.au.